THE OTHER SIDE

"A perceptive documentary portraying three Mexican-born children...and their community in Chula Vista, between San Diego and the border....The lively, thoroughly detailed account is well served by the candid color photos on every spread."
—*Kirkus Reviews*

"These attractive debut titles in the *A World of My Own* series combine lively photography and simple text to introduce two very different communities."
—*Publishers Weekly* on *City Within a City* and *The Other Side*

"The warm, intimate photos show what's special about the kids and their neighborhoods and what is universal." —*Booklist*

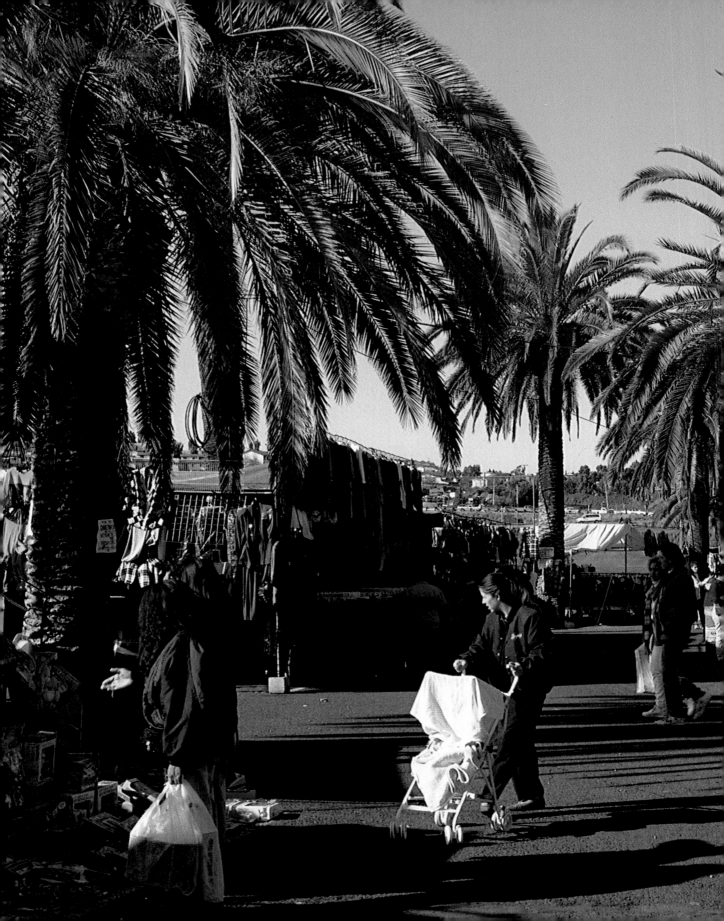

THE OTHER SIDE

How Kids Live in a California Latino Neighborhood

BY Kathleen Krull

PHOTOGRAPHS BY David Hautzig

PUFFIN BOOKS

to Jean Ferris, Sheila Cole, and Larry Dane Brimner,
San Diego companions

—K. K.

to my peers, whose intense drive and tremendous
ability have taught me a lot about taking pictures: Joe Mikos,
Alan Tindell, John Schlesinger, Fran Catania,
Bill Diodato, and Mike Calabrese

—D. H.

PUFFIN BOOKS
Published by the Penguin Group
Penguin Books USA Inc., 375 Hudson Street, New York, New York 10014, U.S.A.
Penguin Books Ltd, 27 Wrights Lane, London W8 5TZ, England
Penguin Books Australia Ltd, Ringwood, Victoria, Australia
Penguin Books Canada Ltd, 10 Alcorn Avenue, Toronto, Ontario, Canada M4V 3B2
Penguin Books (N.Z.) Ltd, 182–190 Wairau Road, Auckland 10, New Zealand
Penguin Books Ltd, Registered Offices: Harmondsworth, Middlesex, England

First published in the United States of America by Lodestar Books, an affiliate of Dutton Children's Books,
a division of Penguin Books USA Inc., 1994
Published simultaneously in Canada by McClelland & Stewart, Toronto
First published in Puffin Books, 1996

1 3 5 7 9 10 8 6 4 2

THE LIBRARY OF CONGRESS HAS CATALOGED THE LODESTAR EDITION AS FOLLOWS:
Krull, Kathleen.
The other side: how kids live in a California Latino neighborhood / by Kathleen Krull ; photographs by David Hautzig.
p. cm. —(A World of my own)
Summary: Depicts the life of two Mexican–American brothers and a girl in
San Diego and their enjoyment of a bilingual culture.
ISBN 0–525–67438–1
1. Mexican–American children—California—San Diego—Social life and customs—Juvenile literature.
2. San Diego (Calif.)—Social life and customs—Juvenile literature. [1. Mexican-Americans—California— San Diego.]
I. Hautzig, David, ill. II. Title. III. Series: Krull, Kathleen. World of my own.
F869.S22K78 1994
979.4'9850046872073—dc20 93–15845 CIP AC

Puffin Books ISBN 0-14-036521-4

Maps by Matthew Bergman

Printed in the United States of America

Acknowledgments

The author gratefully acknowledges the participation of Cinthya Guzman and Francisco and Pedro Tapia and their families, as well as the help of Jorge Castillo, branch manager of the Castle Park Library, and Suzanne Jung, children's librarian, Chula Vista Public Library. Also helpful were Christopher Ewing, children's librarian, National City Public Library; John Rojas and Lynn Pankhurst of the Chula Vista Historical Society; Dr. Olga Vasquez, assistant professor, University of California–San Diego; Dr. Isabel Schon, director of the Center for the Study of Books in Spanish for Children and Adolescents at California State University–San Marcos; Elizabeth McNair for her tour; Hector Burrola; Barbara Fisch; La Nena restaurant; and Virginia Buckley of Lodestar. Special thanks to Jennifer Lyons, Michele Rubin, and especially Susan Cohen, of Writers House.

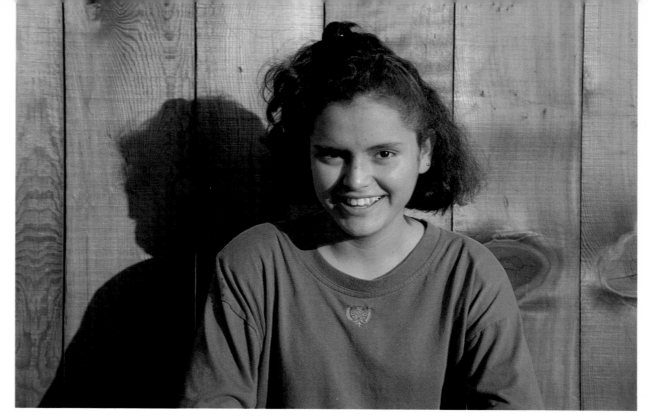

Cinthya Guzman has lived in the United States for four years.

Cinthya has moved from classes in Spanish to classes in English.

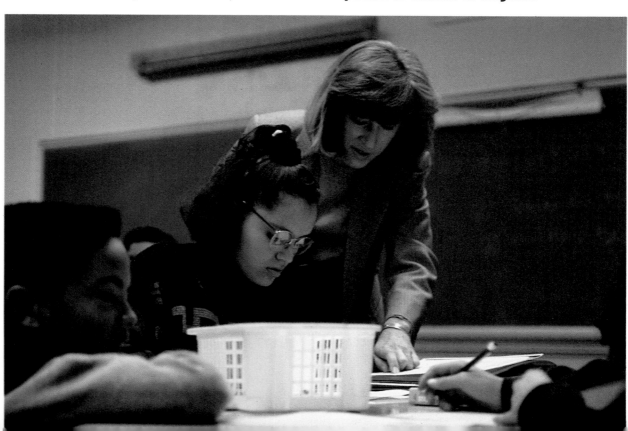

When Cinthya Guzman (pronounced *SIN-thi-a GOOZ-man*) moved to the United States at age eight, her terror nearly got the best of her.

"Every morning I cried hard, because I didn't want to go to school," she says. The idea of a new school, where she understood so little of what was going on, was overwhelming. Her family was worried; her father became so concerned that he offered to move the family back to Tijuana, Mexico. After all, it was only a matter of seven miles.

Cinthya had to reassure him that her misery would pass. And, in fact, after about a month she stopped crying.

At first she was in classes mostly taught in Spanish. Now, at age twelve, she gets straight A's in most of her all-English classes and is completely fluent in both languages. She can't wait for next year, when she will study a third language, French. "I really like languages!" she says.

Francisco Tapia *(fran-SIS-co TAH-pia)*, age eight, also has language concerns. He, too, is bilingual. But lately, especially when he gets angry, he has noticed that he forgets words in Spanish. For instance, when recently trying to say "turkey" in Spanish to one of his Mexican cousins, he couldn't recall the word until after she had left.

This bothers him. His biggest concern is a practical one: "My whole family speaks Spanish, and if I'm not going to be able to communicate with them, my grandma will ask, 'What are you saying?'" This seems to him like a bad dream.

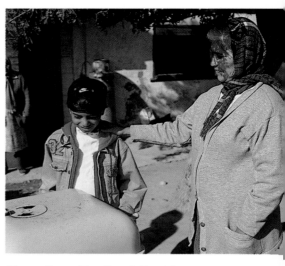

Francisco Tapia visits his grandmother in Tijuana.

Francisco and Cinthya, both born in Mexico, now live in southern California. Their neighborhood, Castle Park, is within a small city called Chula Vista, which means "beautiful view." This is halfway between two tourist destinations, the large city of San Diego and its sister city, Tijuana, or TJ, which is across the border. Californians and other tourists often go there for shopping and entertainment. Tijuana is also a place where people live, many in poverty and overcrowded

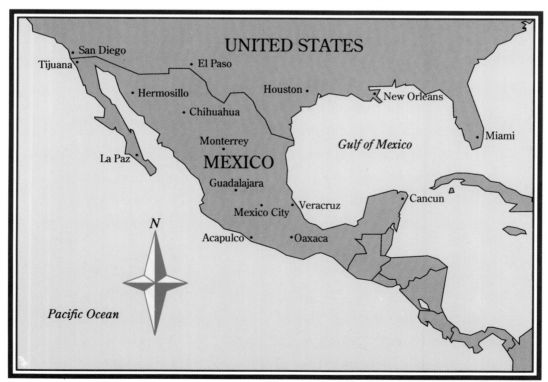

How Did Castle Park Begin?

The first settlers of Chula Vista were various Indian tribes that the Spanish named the Diegueno. Spain took over the land in the 1700s, and it eventually passed into possession of the Mexican government. After Mexico's defeat in the U.S.-Mexican War in 1848, the United States annexed more than half of Mexico, a chunk that included California and most of the Southwest. Racist laws kept many Mexicans from living anywhere except in barrios on the outskirts of towns, and the only available jobs were low-paying ones such as farm work.

Until thirty years ago, the land of Castle Park was used mostly for lemon orchards. Now it is a quiet residential community whose relatively low crime rate and low-income housing attract retired people, first-time home buyers, and new immigrants. No one knows where the name Castle Park *comes from.*

Of the 143,000 people in Chula Vista, 52,000 live in the southwest section called Castle Park. Schools here are approximately 75 percent Latino. The population is expanding rapidly. A huge binational library is being built nearby that will soon replace the Castle Park Library; one-third of the books will be in Spanish, a language that was spoken in this area long before English.

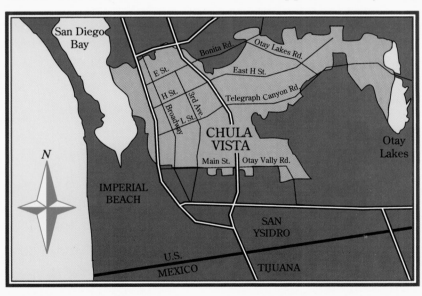

conditions. The minute one crosses the border, one sees women and children begging for money and, off on the hillsides, shacks made of tin and cardboard.

Living only seven miles from Tijuana means that kids like Francisco and Cinthya don't leave their old world behind when they move to the new world. The border between the two countries becomes *el otro lado,* simply "the other side" of their lives.

Castle Park looks like many southern California neighborhoods, which are, in fact, heavily Spanish-influenced. As in Mexico, palm trees are everywhere. Purple jacarandas and orange trees thrive in warm weather under sunny blue skies. This is a suburban, not an urban area—you need a car to get around. License plates frequently read "BC," for Baja California, a part of Mexico. Churches have Spanish names, as do many streets. San Diego and Chula Vista are Spanish names, as are the names of most of the surrounding towns, from El Cajon to La Jolla. Latino kids make use of the Castle Park Library, nearby playgrounds, and parks. You see many more taco shops and other Mexican restaurants than you might see elsewhere. Some signs are in Spanish, restaurant menus can be bilingual, and Mexican history is even in the highway murals.

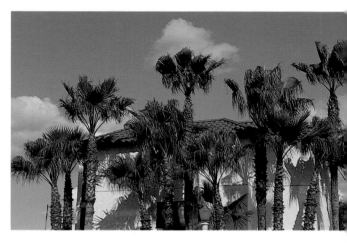

Palm trees and Spanish architecture in Castle Park

Inside the Castle Park Library

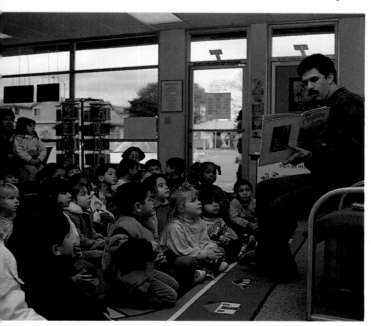

FACING PAGE: San Diego highway murals portray Mexican history.

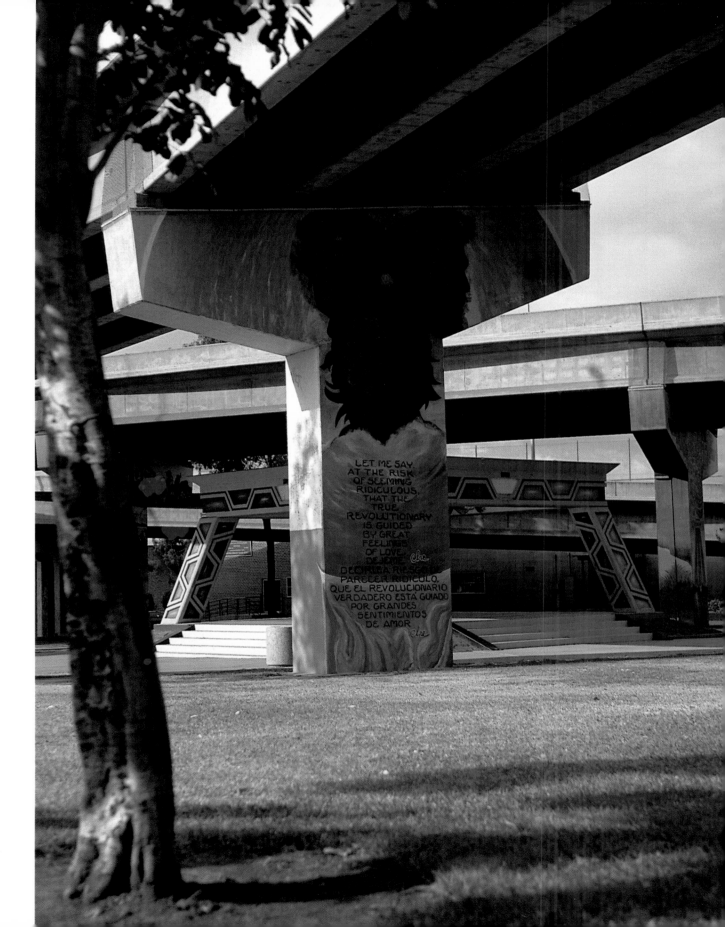

Mexico's Influence on California

Because Mexico used to own California, its influence is everywhere, in place-names, architecture, art, music, food, and the population. Some Mexican families have lived in California for generations; many are recent arrivals. Mexicans enter the country legally, through the San Ysidro or Otay Mesa border crossings, or illegally, through unprotected parts of the border, and sometimes with enormous hardship.

Some people today feel that Mexico is peacefully "taking back" California through immigration, both legal and illegal. In some Los Angeles schools, for example, two-thirds of the students are Latinos.

The birth rate in Mexico remains high, and economic conditions are not improving fast enough. Factories called maquiladoras *(twin plants) bring work from North American companies into Mexico, but constant migration for jobs will continue. San Diego, the largest city near the Mexico-U.S. border, is likely to grow as North American free trade with Mexico increases.*

The words *Latino* (a Spanish word) or *Hispanic* (an English word) can refer to people from various countries besides Mexico, such as Cuba, Puerto Rico, countries in Central or South America, and Spain. People from these countries may feel they have little in common besides the Spanish language. In Castle Park, the majority of Spanish speakers are Mexican or Mexican-American.

The Tapia and Guzman families moved to the United States for the same reason as most other immigrants, to have a better life. Jobs are more plentiful here than on *el otro lado,* and they pay much better.

The two families are in the United States legally, as documented workers with residence papers. Many Mexican immigrants are here

without documents, or illegally, and there is no way to accurately count them. It is estimated that the 1980s saw a wave of four million Mexican immigrants to the United States. It can be difficult to gather information about them. Undocumented Mexicans have no wish to be visible, for fear of being deported. Most are from urban areas. Some are from villages so desperately poor that there are no roads, and they don't realize how fast cars can travel. On freeways around San Diego signs warn motorists to watch out for illegal immigrants trying to cross the freeway on foot. Even so, dozens are killed or injured by cars each year.

Many Mexican immigrants live in San Diego.

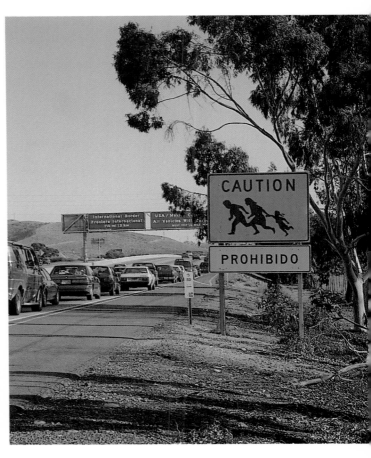

Highway signs warn U.S. motorists to watch for illegal immigrants.

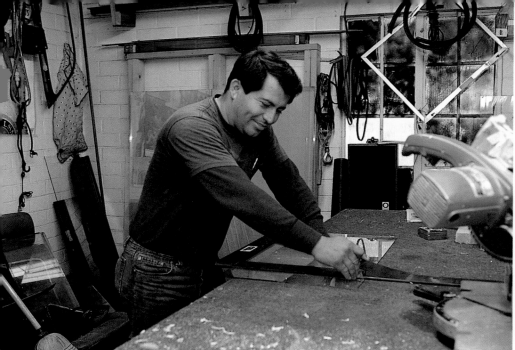

Francisco's father owns his own business.

**The Tapia brothers—
Pedro and Francisco**

Francisco's father got a job here and at first commuted to Tijuana. Then he moved the family to Castle Park, bought a house, and now owns his own glass installation business. Cinthya's father was studying to become a doctor in Mexico, but he dropped out of school to support his family. He assembles planes in the United States. He moved here not so much for himself as for his three children.

"He wanted us kids to have better chances for success," Cinthya explains.

When her father suggested that the family move back to Tijuana to make Cinthya happier, even at age eight she understood why she didn't really want to go. "Here is where I get a better chance for my future," she says. She knows this partly because adults tell her, but she also knows it for herself. "Anyone can see that there are more jobs here," she says, "and that the pay is higher. And in the future, I will want the best for *my* kids."

Getting used to a new school was definitely the hardest part for Cinthya, Francisco, and his brother Pedro, age twelve.

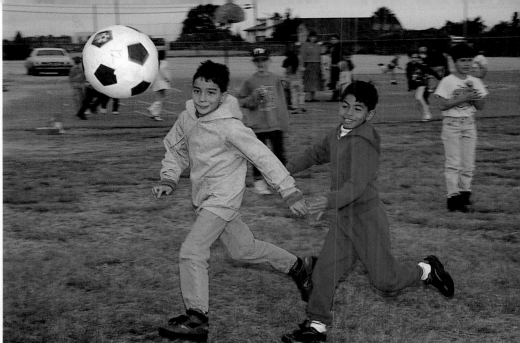

Francisco plays soccer with his friends.

"I didn't know how to explain myself sometimes," Pedro says. Homework was mystifying. When playing with new friends he used a sort of sign language.

For some kids, how to ask the teacher where the bathroom is might be their very first sentence in English. Pedro recalls his first English sentence, "I need help." For Francisco, it was, "I don't know." Now, after living here several years, they speak fluently. Cinthya recalls how "nice the teachers were" in helping her to adjust.

As the kids worked to reach their appropriate grade levels, they passed from all-Spanish classes to bilingual to all-English classes. For Pedro, learning English was "pretty quick"—a matter of months, he recalls. He thinks that his younger brother, Francisco, learned English even faster, mostly from playing with his friends rather than formally learning it in school. Both boys notice that although they had to learn English in order to communicate, their American friends rarely learn Spanish.

Many of the kids are more comfortable speaking English than

their parents are. Pedro and Francisco's parents, for example, use Pedro as a translator. They always have him answer the phone, so that he can traffic the calls. He says hello, then switches languages, depending on who the caller is.

Although the parents speak mostly Spanish, they are going to classes to learn English. The brothers help their mother with her

Pedro always answers the phone at his house.

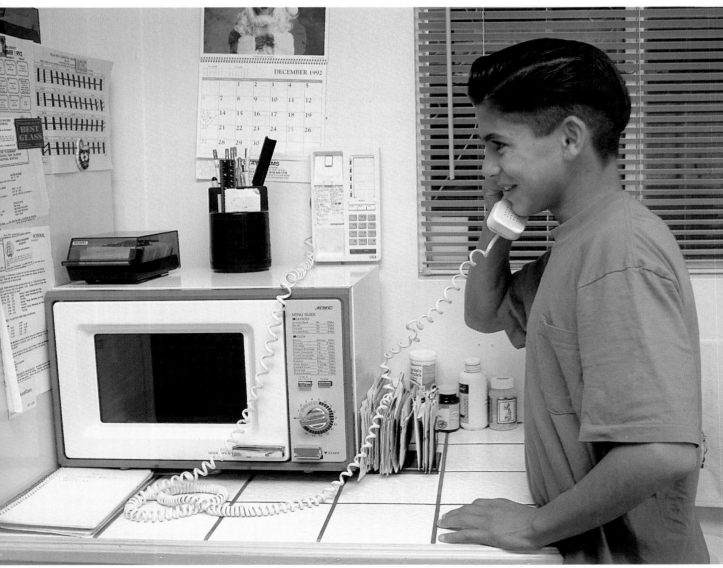

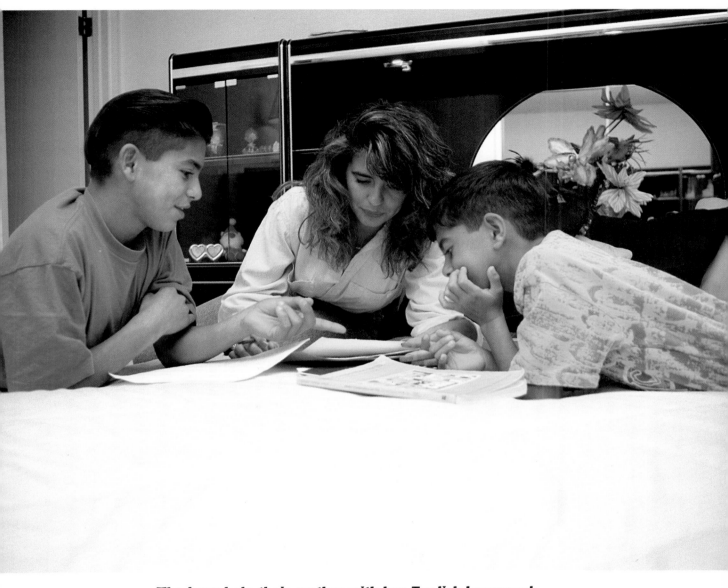

The boys help their mother with her English homework.

assignments and even tease her about her "funny accent." The extra responsibilities do not bother them. "She helps us; we help her," says Francisco. "That's not strange to us. It's normal." Many of their friends are in the same situation. They know the language of their new country, but their parents don't.

17

Around home the family speaks Spanish. "If you speak English, it sounds kind of funny," says Pedro. "It doesn't feel right." Their encyclopedias are in Spanish, as are half their books. Pedro can read and write in Spanish, but Francisco can't read that well in Spanish. He is learning how, with help from his family and books from the library.

Cinthya's family speaks Spanish at the dinner table. Her parents worry that she might start losing her Spanish. Many Latino parents feel strongly that their children should be bilingual and bicultural. They think that their children's success will depend on absorbing the best of the new world while keeping the best of *el otro lado*. They think that success in the United States today is impossible with one language only.

For previous generations of immigrants, there was no going back. Once they were in the United States they became "American" as quickly as possible. Some new Americans feel that emotional damage accompanies this cutting off of one's ties. The closeness of their homeland, however, allows Mexican immigrants to handle life in their new country differently.

When they visit Tijuana, Cinthya's parents warn her to speak Spanish. "It does make me uncomfortable speaking English in Tijuana," she says. She's not worried that she'll stand out, rather that her "cousins will think I'm talking about them."

With her friends in the United States she speaks English. She switches to Spanish "mainly when I'm angry." If she loses her temper with her nine-year-old sister, Brenda, for example, she might speak to her in Spanish, but not to soften her anger. "It just comes out that way." She dreams in both Spanish and English.

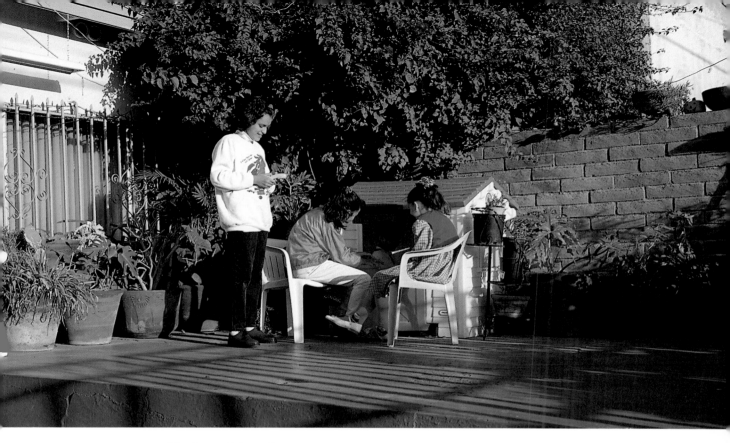

Cinthya visits with her cousins in Tijuana (ABOVE) and
with her friends in the United States (BELOW).

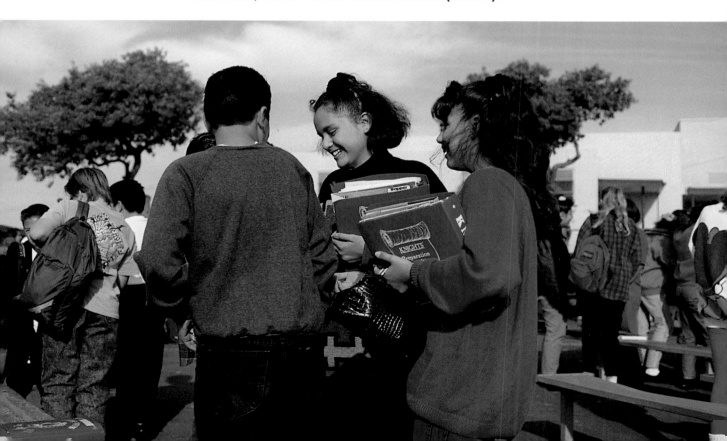

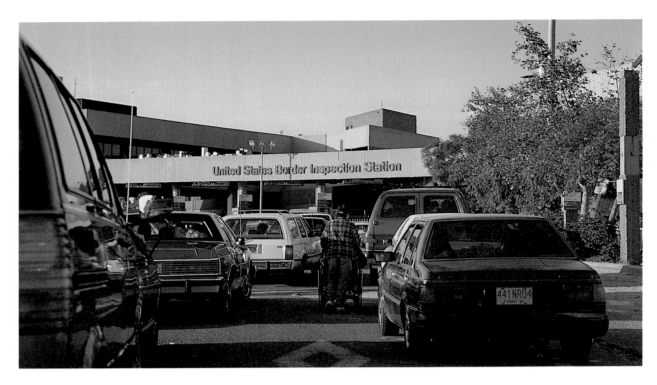

Crossing the U.S.–Mexican border, from both sides

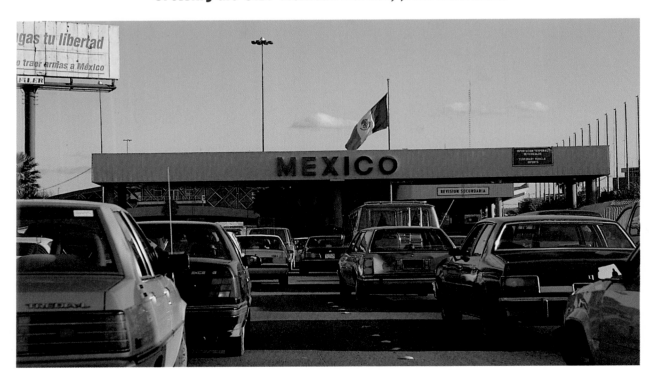

Pedro's favorite treat in Tijuana—flaming mangos

Knowing two languages seems to Cinthya a distinct advantage: "If you know English and Spanish, you can be a teacher or translator." This strikes her as one of the good things about the United States—that she gets to speak two languages here.

The chances that children will lose their Spanish are slim. Many children have frequent opportunity to speak it. They're always translating for their parents or helping the steady stream of newly arriving Mexican friends or family members.

Also, there are numerous ways Mexican culture tends to be preserved. With no ocean to navigate, crossing the border is usually easy compared to what immigrants from Europe or Asia have to do. Families always know that if things don't work out for them here, they can easily return. Meanwhile, they can pass back and forth for family parties, temporary jobs, doctor visits, shopping, and even to satisfy food cravings—a dessert called flaming mangos for Pedro, certain kinds of tacos for his parents. Phone calls between the countries are comparatively cheap.

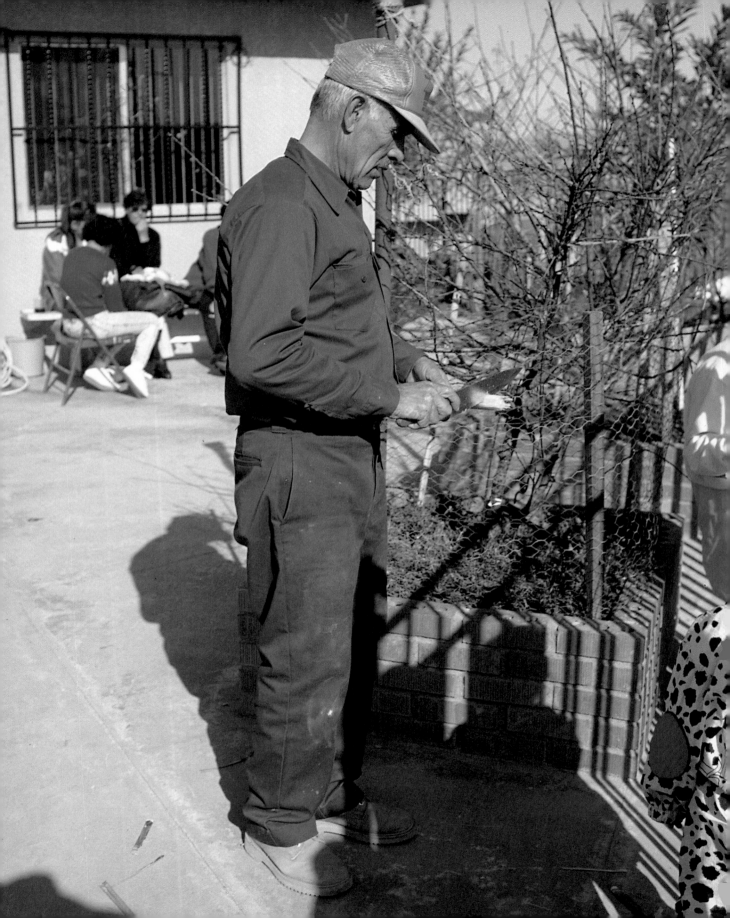

Almost every weekend, the Tapia brothers go to TJ to be with aunts and uncles (they have eleven), to explore neighborhoods with their cousins, to eat fresh sugarcane from their grandfather's garden. All their doctors and dentists are in Tijuana, where the cost of medical care is lower. On family vacations, they travel around Mexico. In the United States, they have never been outside California. In San Diego, they rarely go to areas that aren't primarily Latino.

Cinthya goes to TJ once or twice a month, visiting her cousins (she has ten), aunts, and uncles. She buys her toys and baseball cards there, shops at malls, and especially likes visiting her grandfather's house. He buys her candy down at the corner store.

FACING PAGE: Pedro and Francisco's grandfather in his sugarcane garden

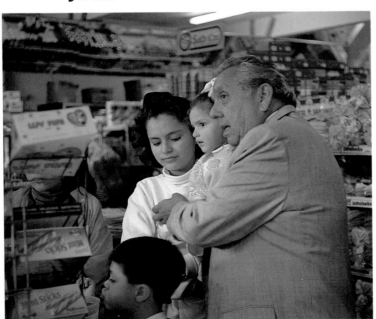

ABOVE: The boys explore neighborhoods in Tijuana.

LEFT: Cinthya buys candy with her grandfather.

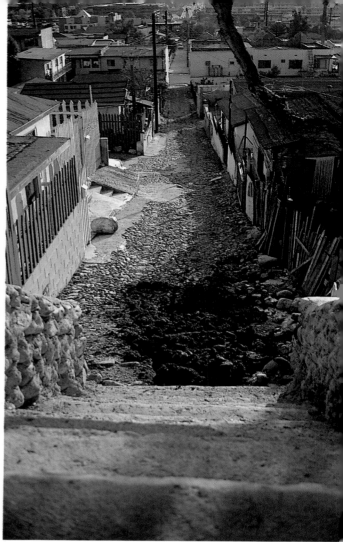

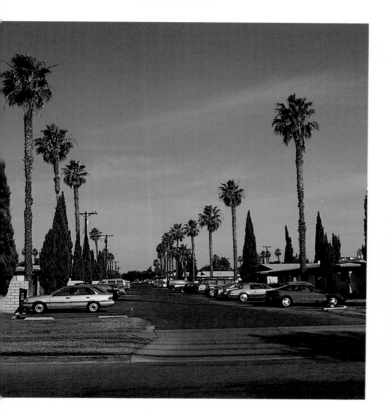

Cinthya feels equally at home in both countries. She likes the fact that "it's cleaner in the United States, not as crowded." The main thing she doesn't like about this country is that there seem to be more gangs here. She thinks gangs, both local and from outside the area, are a problem at her school; they don't bother her, but "you just know they're going to do something bad." She is nervous about the job situation—she hates to see people losing their jobs—and also about pollution, which she thinks is getting worse on both sides of the border.

What made the greatest impression on the Tapia brothers when they first moved to the United States was "new stuff." Buildings seemed newer, and streets were paved, not rocky as in Mexico.

"Schools are better here," Pedro adds. Their neighborhood also is better, with "more people and friends closer to us." In general, the Tapias prefer the United States. But they miss family. The best thing about Tijuana is that most of their relatives live there.

The majority of the kids in Castle Park schools are Latino. The minority is a mixture of white (or Anglo), Asian, and black. Pedro's impression is that kids get along at his school. Teachers are strict and will send kids to the police station for fighting. Since he is bigger than most kids in his school, he rarely gets picked on. His friends are mixed. He says that he just looks for kids he likes. His best friend is his next-door neighbor, who was born in Chula Vista to Mexican parents.

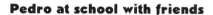

Pedro at school with friends

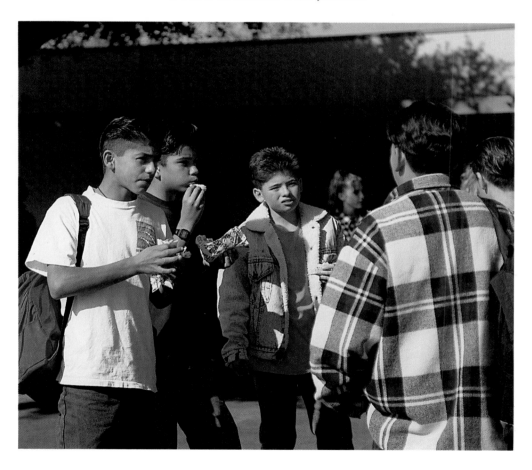

Stereotypes

Old Hollywood movies portray Mexicans as cruel bandits, or as childlike, even stupid. Even today, some people blame "stupidity" for problems ranging from immigrants' language difficulties to their illegal status. Schools used to put Mexican children who could not speak English into classes for the mentally retarded. Such stereotyping ignores the individuality of kids like Cinthya, Pedro, and Francisco.

The high-school dropout rate for Mexican-Americans is high, however. Generations of Mexicans have made their living in ways that do not require formal education, such as farming, art, or working for others in service jobs. If a family is poor, it is hard to see education as more important than immediate needs. Also, language difficulties and negative attitudes can frustrate kids to the point of leaving school. If there are problems within the family, many Mexicans, assuming that social service agencies will treat them like second-class citizens, are reluctant to seek help.

Mexicans can have negative attitudes about Anglos. They may think that people in the United States do not know how to enjoy life, prefer material goods to family happiness, are less affectionate and emotional, are too concerned with appearances, and are immoral—especially women. Mexicans who return to Mexico may be called gringo or American—and these are not compliments.

Most of Francisco's friends are Anglo, because there are more Anglos at his school. Sometimes kids at school tease one another or fight at recess. Francisco's response is either to ignore such trouble or to tell the teacher.

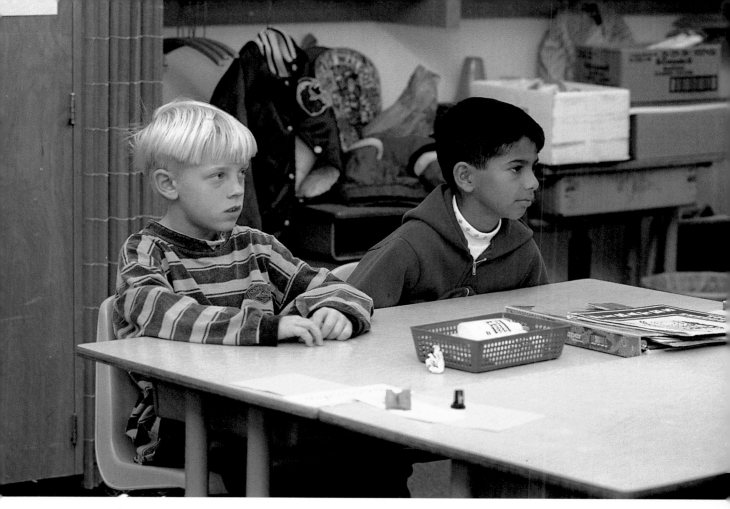

Francisco at school with an Anglo friend

Neither Francisco nor Pedro feel that they are discriminated against for being Latino. Their sense is that blacks suffer more from discrimination than they do.

Cinthya's school is more than half Latino, and she hasn't noticed any problems between groups. Her best friend was born in Los Angeles to Mexican parents.

In Castle Park, kids do more things with their families than with friends. This fits in with traditional Mexican culture, where the family and respect for parents are all-important. Relatives sometimes live together in extended families, and they help one another out to an unusual degree.

Castle Park parents bring their kids to the library, and kids also bring their *parents* to the library, making it one of the five busiest libraries in California. A large mural of children who have lived in the area greets them at the circulation desk.

Library mural of Castle Park children

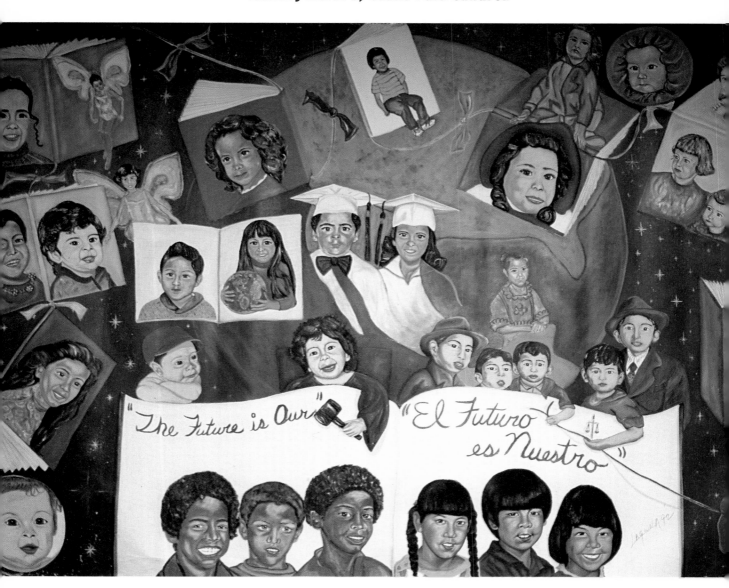

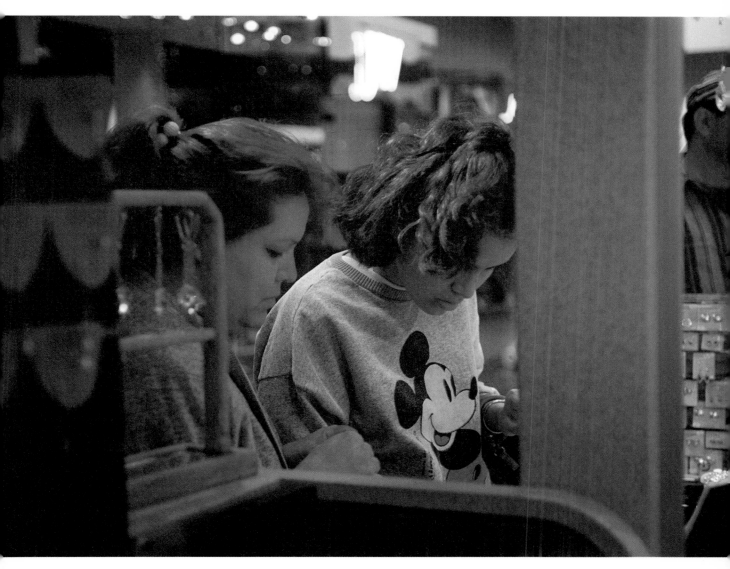

Cinthya goes shopping with her mother.

On weekend evenings at Cinthya's apartment, the family rents videos and orders pizza or Chinese takeout. At malls, Cinthya goes shopping with family, not friends. Her dad lets her play outside only during the day, for fear of crime, and then only for a certain number of hours.

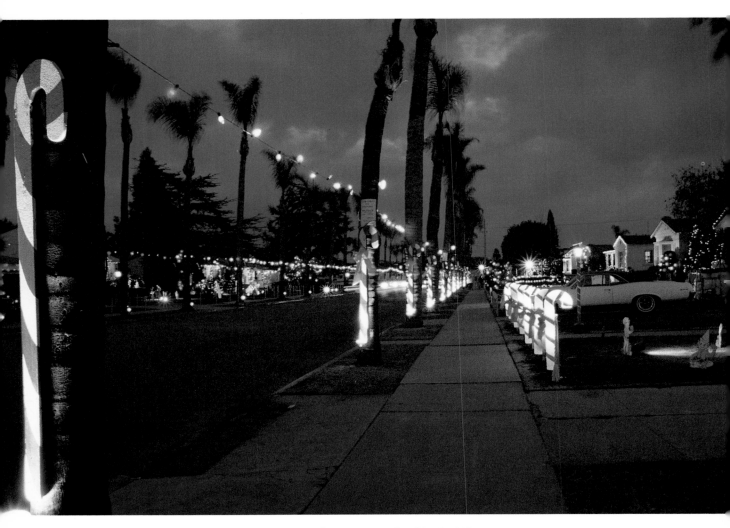

Candy Cane Lane in Chula Vista

"I mostly do stuff with parents," Pedro says. They might go to the movies together, or to Tijuana for family parties. At Christmas they may visit Candy Cane Lane, a street in Chula Vista that goes wild with decorations. He plays football and soccer with friends, but when he bodysurfs at nearby Imperial Beach in the summer, he goes with his mom and brother. When his parents "actually let me do something outside," he gets in trouble if he's late getting home.

Francisco's trouble spots are talking back and doing things his

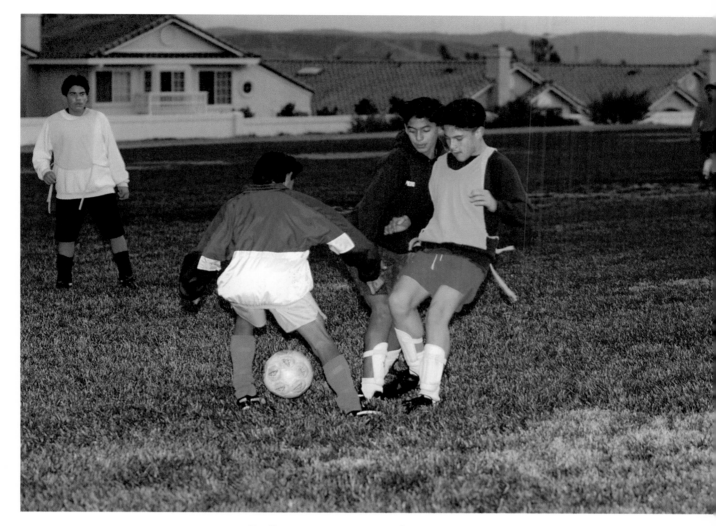

Pedro at soccer practice

mother says not to. The brothers also face disapproval from their parents if they neglect homework or fight—for instance, over whose turn it is at Super Nintendo. Punishment is a "big lecture" in Spanish or being sent to their rooms. (Each brother has his own bedroom.)

The same punishments befall Cinthya if she fights with her siblings, fails to wash the dishes when she's supposed to, or on the rare occasion when she gets an F on a test.

What makes Francisco angry is when his mother needs his help

to pick things out in a store and insists he go shopping with her. "Come with me; come with me," he imitates. Sometimes teachers upset Pedro, as when they tell him to go outside for the rest of the period because he's been talking or fooling around.

The Tapia brothers collect comic books and baseball cards, take care of their pet python and dog, Peluchin, and read sports books. At school Pedro plays drums in the band, acts in talent contests, and competes in a soccer league. They both love rock 'n' roll—from the United States, not Mexico. Francisco calls Mexican rock music "parent songs," too slow or something only older people listen to. When playing the radio, the boys have a deal with their parents that lets them pick the station half the time.

Both brothers help their father at work. With his allowance, Pedro saved enough last summer to buy himself a body board, wet suit, and fins. Francisco spends what money he receives on toys. He doesn't like to save it. Once his savings reach a certain point, then "the money wants to get into somebody else's hands."

FACING PAGE: Going bodysurfing at Imperial Beach

BELOW: Playing with Peluchin, the dog

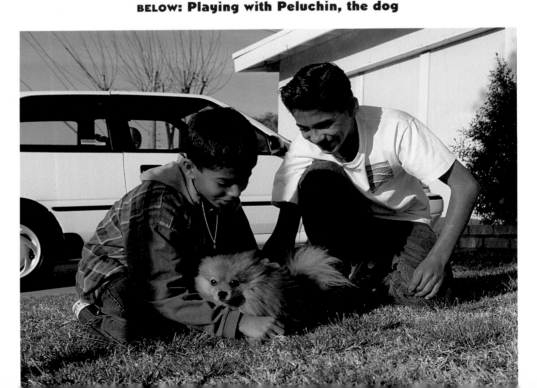

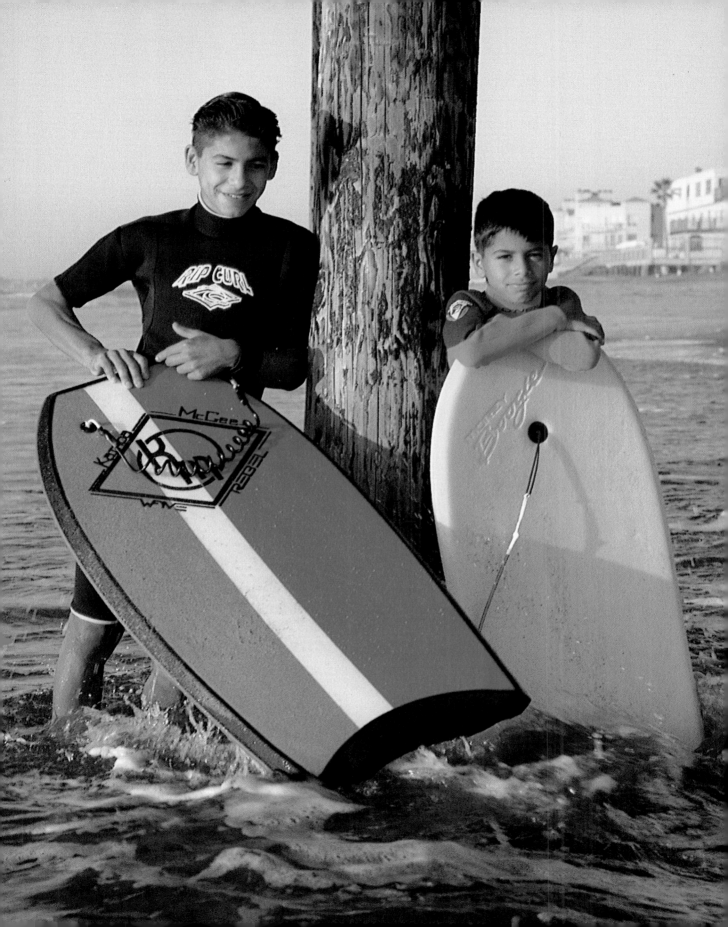

In addition to her allowance, Cinthya sometimes sells things at swap meets to make money. With her money she buys earrings and tries to save enough to buy CDs for the CD player she got for Christmas. Her favorite music is rap.

TV can be a source of information about both Mexican and American culture, and families discuss programs while they watch. Cinthya does follow one soap opera (called a *telenovela*) on Spanish TV, but otherwise watches regular programs in English. Francisco likes car-

Cinthya buys and sells things at swap meets.

toons, and Pedro looks at "whatever's on." Neither of them watches Spanish TV.

For the Tapia brothers, birthdays have a Mexican accent. They enjoy presents, cake, and a papier-mâché piñata. "Candy pops out, like an egg," explains Francisco, and that includes peanut brittle, glazed orange rinds, sugared pumpkin, and coconut squares. The goal is to try to grab as much as you can. All the relatives come over, from TJ as well as Chula Vista.

Piñatas are used for celebrations in Mexico.

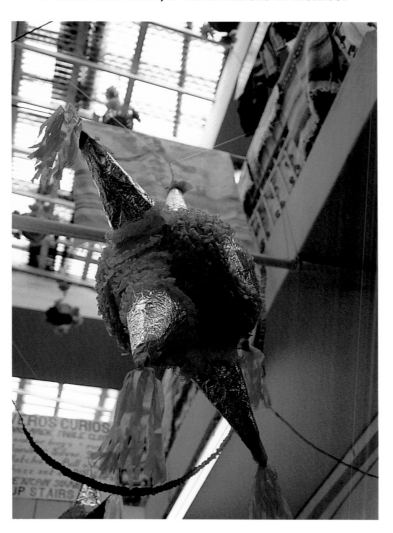

For Cinthya's birthday, her mother makes *posole,* her favorite soup. She says she's "too old for a piñata." It doesn't feel right to her. Her family has piñatas in TJ, on holidays such as New Year's and Mother's Day.

A significant number of Mexicans are either Protestant or in the process of converting to a Protestant religion, such as Mormonism. But like the majority of Mexicans, the Guzmans and the Tapias are Roman Catholic. Neither family regularly attends church, however. Cinthya occasionally goes to a church in Tijuana, where she likes the singing, but at home she's likely to go to church only when she wants to pray for something. The Tapia brothers attend Catholic school on Sundays to get ready for First Communion. They spend the night before Christmas at their grandmother's, where they stay up until 1 A.M. to open presents and light firecrackers, which are legal in Tijuana.

In Mexico, the Days of the Dead *(Los Dias de los Muertos)* rival Christmas as the most important holiday of the year. Combining Spanish Roman Catholic and ancient Indian beliefs, November 1 and 2 are a time when the living and dead are reunited. Most people visit the cemeteries to decorate their family's graves and keep vigil there. In the United States, some Latino families make a point of maintaining this tradition, while others prefer its North American cousin, Halloween.

Cinthya, for example, does not celebrate the Days of the Dead, and her family has never gone to cemeteries on these special days. On Halloween, she goes trick-or-treating.

Francisco and Pedro celebrate both. On the Days of the Dead, "We go and visit family members in the Tijuana cemetery—over there is where all our dead are." They also trick-or-treat, Francisco going as the Grim Reaper with a moldy mask, Pedro as a corpse with noodles dyed red coming out of his stomach. Which celebration do they like better? Halloween for now—because of the candy.

FACING PAGE: Folk art related to the Mexican Days of the Dead

36

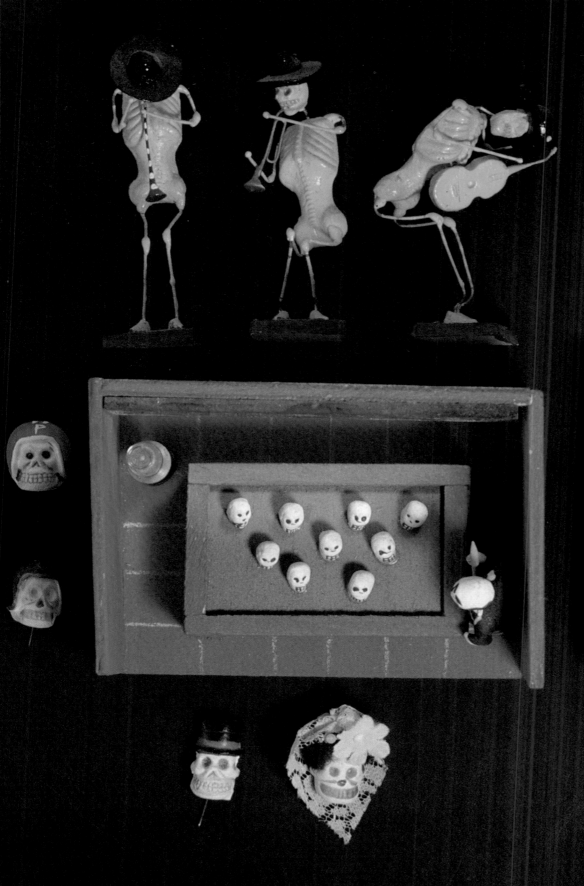

Mexico's Cultural Offerings

Contributions that Mexico has made to the world include the number zero (from the great Mayan and Aztec civilizations); numerous words in the English language (such as cafeteria, tornado, tomato, alligator, macho, vanilla); Mexican folkloric dancing; fabrics in bright colors and bold designs; fine jewelry using turquoise, silver, and other valuable metals; beautiful sculpture and pottery and folk art; painters such as Diego Rivera and Frida Kahlo; a distinctive style of architecture; new foods (chocolate, avocados, turkey, and pineapple) as well as a whole new way of looking at food.

Ancient Indians in Mexico invented the barbecue. Later Mexicans created a popular style of cooking used to prepare the familiar tacos, enchiladas, burritos, tamales, and tortillas of today. Mexican restaurants are all over the United States now, especially in the Southwest, where they used to be the only restaurants that would serve Mexicans. People have come to love the zingy flavors of jalapeño peppers; chorizo (sweet spicy sausage); zucchini blossoms stuffed with cheese; panuchos, or tortillas filled with black-bean paste covered with lettuce, chicken, and pink pickled onion rings; tangy sauces such as guacamole, salsa, and mole (made of chocolate and roasted chiles); soups such as sopa de nopalitos (made with cactus paddles) and posole (shrimp, ground almonds, tomatillos, and cilantro); chalupines (deep-fried grasshoppers); and many other dishes. For dessert, try Mexican hot chocolate (with cinnamon), arroz con leche (warm rice pudding); or paleta (fruit popsicle).

Mexican pottery

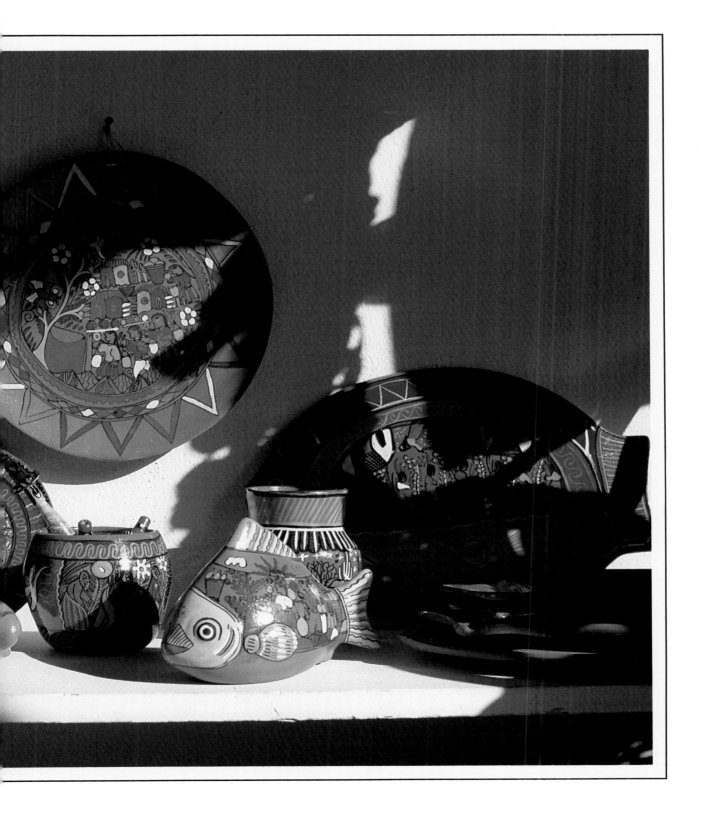

Cinthya likes Mexican food, which she eats at home, and also Chinese food. Francisco and Pedro eat Mexican food at home—beans, rice, a lot of tortillas, enchiladas, and omelets. Francisco likes *quesadillas* and bean burritos. Pedro likes *carnitas* (chunks of pork) and Mexican buffets where you can pick what you want. In general they prefer Mexican food to American, except for Francisco's all-time favorite: "I bet *every* kid likes pizza. Pizza is like a secret thing that all kids know."

As for the future—it is open for Mexican children in a way it seldom is for other immigrants.

Pedro and Francisco say that when they grow up they will definitely live in the United States. But after thinking some more, Pedro decides he might move back to Mexico, perhaps somewhere farther south, "where it's much nicer than Tijuana." Once they have financial security in this country, some Mexicans choose to return to where the cost of living is lower. For instance, they could own a nice house in Mexico for the same money they pay in rent here. Also, they may not think of the United States as "home" and may feel happier in Mexico.

Francisco looks out over Tijuana.

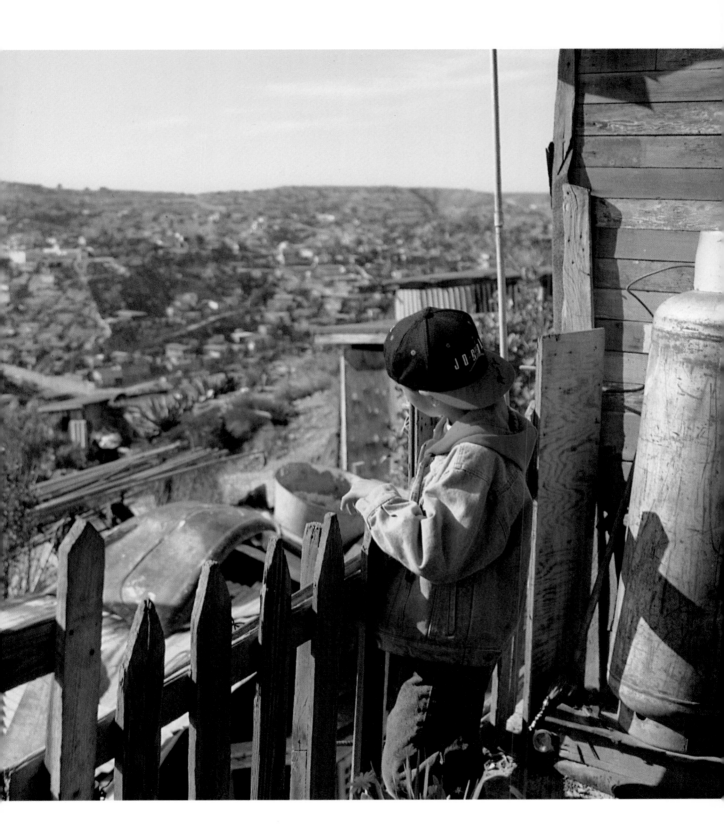

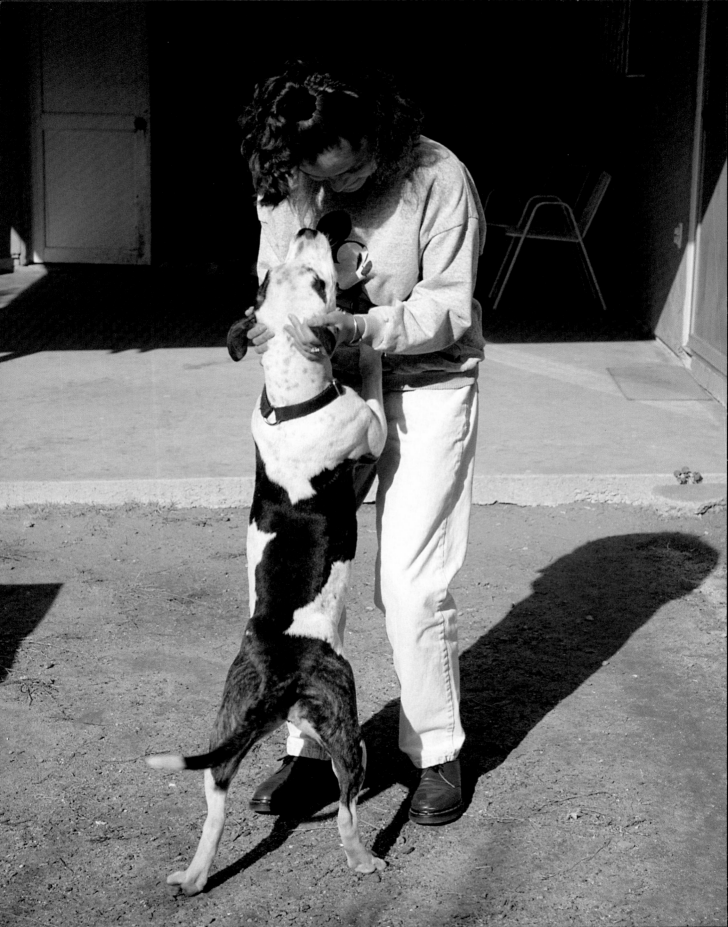

Pedro doesn't know yet what he would like to be when he grows up, only that for now he loves sports, especially soccer. Besides band practice, his two favorite classes in school are English and world cultures. He likes learning about the history of other countries. Francisco says he "wants to be a policeman, or if not that, then a baseball player or a professional wrestler."

Cinthya is thinking about becoming a nurse, though she worries that "if I make a mistake I could kill a person." She likes pets enough to think about becoming a veterinarian. She's interested in computers, and she also wonders about being a lawyer. "They make good money," she says, "and I do like defending people."

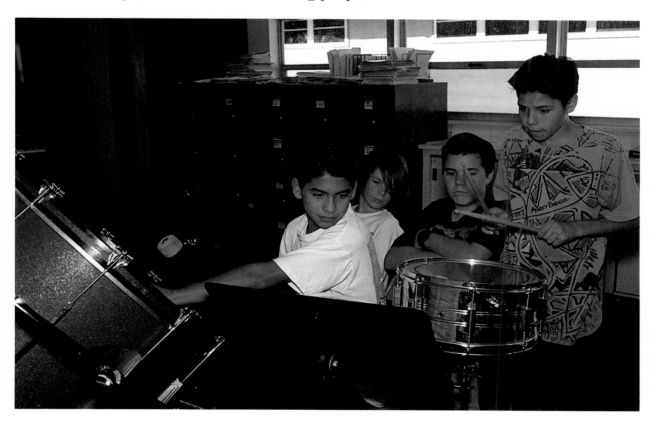

Pedro at band practice

FACING PAGE: Cinthya plays with her uncle's dog.

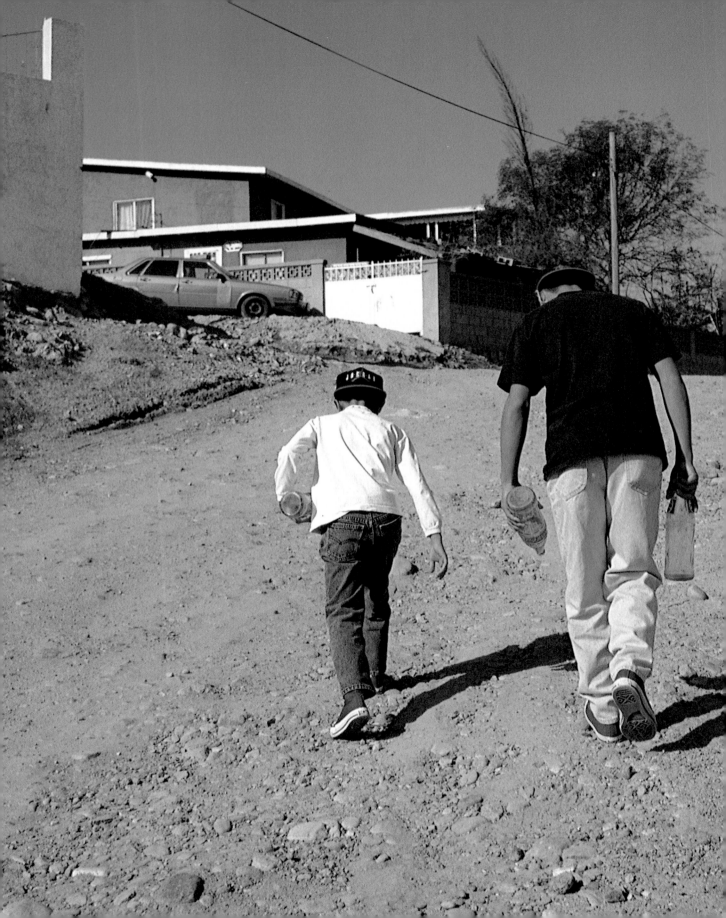

Cinthya, Francisco, and Pedro are likely to attain their goals regardless of their eventual home. This direction seems to come from within, with help from their parents and relatives. The Tapia parents' biggest goal for their sons, for example, is that they go to college. Cinthya's grandmother has promised her house to the first grandchild to become a doctor. And her father has made another promise: "If my grades are high enough," she says, "my dad says he is going to buy me a computer for Christmas."

With eleven A's and one B+ on her last report card, the chances for success look good.

The Tapia brothers, off to buy soda in Tijuana

For Further Reading

Brimner, Larry Dane. *A Migrant Family*. Minneapolis: Lerner, 1992.

Brown, Tricia. *Hello, Amigos!* New York: Holt, 1986.

Catalano, Julie. *The Mexican Americans*. New York: Chelsea House, 1988.

Hewett, Joan. *Hector Lives in the United States Now*. New York: Lippincott, 1990.

Meltzer, Milton. *The Hispanic Americans*. New York: Crowell, 1982.

Morey, Janet, and Wendy Dunn. *Famous Mexican Americans*. New York: Cobblehill, 1989.

Pinchot, Jane. *The Mexicans in America*. Minneapolis: Lerner, 1989.

Poynter, Margaret. *The Uncertain Journey: Stories of Illegal Aliens in El Norte*. New York: Atheneum, 1992.

Shalant, Phyllis. *Look What We've Brought You from Mexico: Crafts, Games, Recipes, Stories and Other Cultural Activities from Mexican-Americans*. New York: Julian Messner, 1992.

Shorris, Earl. *Latinos: A Biography of the People*. New York: Norton, 1992. (for adults)

West, John O. *Mexican-American Folklore: Legends, Songs, Festivals, Proverbs, Crafts, Tales of Saints, of Revolutionaries, and More*. Little Rock: August House, 1988. (for adults)

Westridge Young Writers Workshop. *Kids Explore America's Hispanic Heritage*. Santa Fe: John Muir, 1992.

Index

Page numbers in *italics* refer to photographs and maps.